Between 1978 and 1980, David Wojnarowicz created the *Arthur Rimbaud in New York* series, nearly five hundred black-and-white photographs of someone wearing a Rimbaud mask in New York City and its surrounds.[1] The photographs say, "He would have visited Coney Island"; "He would have seen porn in Times Square"; "He would have eaten a hamburger and fries." Spotting the nineteenth-century French poet in the Big Apple is more than delightful. We, whoever feel addressed by him, are like him, and he is a source for our identification, a root for our identity. He is also isolated and alone. When he stands on the subway platform, everyone faces away from him. When he goes to Coney Island, the often overcrowded and public place is empty. In one photograph, the figure lies beneath someone, but our Rimbaud might as well be alone.

[1] Cynthia Carr, *Fire in the Belly: The Life and Times of David Wojnarowicz* (New York: Bloomsbury, 2012), 156.

The image on the mask is a reproduction of the Étienne Carjat portrait, which Rimbaud biographer Graham Robb reminds is "now the face most often associated with Rimbaud."[2] Wojnarowicz likely copied the image from the cover of the New Directions edition of *Illuminations*.[3] In this portrait, one of the few photographs that exist of the poet, the seventeen-year-old looks away at something we cannot see.[4] "A faraway look has been obtained."[5] The forever-young Rimbaud appears wise beyond his years. He looks both to the future and to the past, where infinite possibility meets a condensation of time, where what has not yet happened converges with what already has. For Robb, this is "a picture of Rimbaud pretending to be a poet."[6] But Rimbaud will be a poet and, for many of us who identify with the New York Downtown scene, Rimbaud will have felt like *our* poet. And he, whoever he is, has been representing us, whoever we are, for a long time.

> The name of Arthur Rimbaud must not be omitted from our galaxy. We are Rimbaudists without our knowing or liking it. He is the patron of our many poses and flights of fancy; he is the star of modern aesthetic desolation.[7]

In this description by Hugo Ball, Rimbaud represents something beautiful and hurting: when we identify as Rimbaudists, as Ball suggests, we create a society of outsiders who belong together.

2 Graham Robb, *Rimbaud: A Biography* (New York: W.W. Norton & Co, 2000), 140.
3 The image is central to the covers of a number of editions, including the most recent English-language translation, by John Ashbery.
4 Robb, *Rimbaud*, 174. Robb dates this portrait to December 1871.
5 Ibid., 140.
6 Ibid.
7 Hugo Ball and John Elderfield, *Flight Out of Time: A Dada Diary* (Berkeley: University of California Press, 1996), 68.

But Wojnarowicz's Rimbaud is a mask for someone *outside* of social life. This Rimbaud is not our Rimbaud. He is not the one Patti Smith addresses when she yells "Go Rimbaud! Go Rimbaud!" nor is he the one who shot his boyfriend (the poet Paul Verlaine), traded arms, or either did or did not trade enslaved persons. This is to say that whatever we know, or think we know, about Rimbaud's life, *this* Rimbaud is genuinely other—a symbol for the effacement of biography itself. *This* Rimbaud is unseen, separate from everyone who surrounds him. *We* have never met *this* Rimbaud.

WOJNAROWICZ'S SERIES FOREGROUNDS the difference between the Rimbaud poet-image and a Rimbaud for whom there is no identification and no identity. Feeling without a self—feeling accompanied by a sense of not having a self or of being too far outside a self—can lead to suicidal fantasy, and suicide is an overt possibility in the series. In one photograph, Rimbaud appears to have overdosed. In another, he points a gun at his head. And in another, he lies on the ground as if he has just shot himself, the gun still in his hand. The repeated presence of the mask—a face that never changes—yields a feeling that never changes. This erasure—repetition without difference—reflects the lack of recognition of a person, a vacuum that, in turn, suicidal fantasy ventures to resolve.

Arthur Rimbaud in New York gestures both toward and away from suicide, reflecting the ambivalence at the heart of the act and the fantasy.[8] Rimbaud, our "star of modern aesthetic

8 Kay Redfield Jamison, *Night Falls Fast: Understanding Suicide* (New York: Knopf, 1999), 39. Jamison writes, "ambivalence saturates the suicidal act."

desolation," resembles those whose suicides solidify their stardom. The fantasy of killing oneself offers a solution to the problem of being nothing, of being far away, looked at but not engaged with, where "oneself" becomes lost in the sky, nearly impossible to connect with and identify. A lack of identity and the absence of distinct forms of identification constellate important aspects of suicidal fantasy, where what can drive the fantasy is fantasy itself. Put another way, it is hard to know whom I want to kill when I want to kill myself because I do not feel like anyone to begin with. Suicide, like the problem of feeling like no one and nothing, confuses subject with object (or live person with dead person) and recalls the experience of being objectified, being made to feel dead. In dreaming of taking my life, I hope to take complete control over my life so that I can truly live. And if I kill myself, then everyone will see me and I can actually survive.[9]

The dream of survival that constitutes the fantasy comes to be expressed in Wojnarowicz's series through the mask. The mask of Rimbaud's face, rather than the image or picture on the mask, indicates the need for a witness. But in order to witness erasure, the witness must maintain a gap. The one who has not been seen, recognized, or identified with as distinct does not want to hear "I see you" as a positive thumbs-up to their suffering. This erases the experience of being unseen. The Rimbaud mask offers a figure for a witness to a life unseen and the dream of having survived that life.

9 Sigmund Freud, "Mourning and Melancholia," in *The Complete Psychological Works of Sigmund Freud, Vol. 14 (1917)*, trans. James Strachey (London: Hogarth Press, 1957). Freud describes how aggressivity and destructiveness undergird experiences of relentless loss when he tells us that suicide is the logical conclusion of melancholia.

THE DOWNTOWN SCENE was, Marvin Taylor writes, "synonymous with experimentation," and for many, experimentation also included self-destruction.[10] Cynthia Carr describes this in an essay for the catalogue of *Fever*, the first retrospective of Wojnarowicz's work after his death:

> The East Village had a grim, self-destructive edge. Some of the best work it produced (*and* some of the worst) was violent, gross, and pointedly transgressive. For a long piece he wrote about a friend's suicide, David taped interviews in which he asked people, "What attracts you to the dark things?" He felt the pull himself.[11]

Destruction and self-destruction interested Wojnarowicz. Mysoon Rizk, like many other critics, describes "the artist's recurring sense of imminent death."[12] Often contextualized by the AIDS crisis, Wojnarowicz's sense of death was more often than not coupled with murderous rage and emerged in a range of contexts. In particular, Wojnarowicz shows us how much pleasure there is to be had from imagining killing people. In an unfinished film, *Where Evil Dwells* (1985), Wojnarowicz and his friend and collaborator Tommy Turner partially re-enact a news story about a boy who killed his friend as part of a Satanic ritual. In another film, directed by Richard Kern, Wojnarowicz plays an abusive patriarch and the husband of an absurdly oblivious mother (played by performance artist Karen Finley). The film culminates in their androgynous teen shooting the whole family while shouting, "You

10 Marvin J. Taylor, editor, *The Downtown Book: The New York Art Scene, 1974-1984* (Princeton, NJ: Princeton University Press, 2006), 17.

11 David Wojnarowicz, Dan Cameron, and Amy Scholder, *Fever: The Art of David Wojnarowicz* (New York: Rizzoli, 1999), 83.

12 Ibid., 49.

killed me first." Wojnarowicz was also in a band called 3 Teens Kill 4, which is said to refer to yet another murder headline.

These films are exceedingly gory. The commitment to fakery in what gets dubbed the Cinema of Transgression bleeds into a desire for something beyond the borders of art: the desire for art to be more than itself, to alter life in an immediate and permanent way.[13] In *Where Evil Dwells*,[14] we see a group of people preparing to drop a dummy off an overpass and onto the freeway. The dummy apparently jumps off the bridge and lands on a car being driven by Wojnarowicz. In other words, a suicidal doll meets a performance of man-slaughter. Had this game gone sideways, it could easily have caused an accident. In art that explores cruelty, maintaining a distinction between real danger and fake danger is often untenable.[15]

The idea of Rimbaud being a tourist in New York, a seemingly benign fantasy compared to that of *Where Evil Dwells*, was part of Wojnarowicz's original vision for the series. His unpublished journals outline many places he imagined taking photographs of Rimbaud. He refers to "shooting Rimbaud" in Chinatown, at the Empire State Building, "making rude gestures in st. patricks [*sic*] cathedral during mass." Wojnarowicz also imagined taking photographs of Rimbaud during both the day and night and "among the winoes [*sic*] in the bowery";

13 Nick Zedd [Orion Jeriko], "The Cinema of Transgression Manifesto" in *Feast of Hate and Fear*, (1985). Turner, Kern, and the poet Lydia Lunch, among others, were part of this underground New York film movement. Zedd writes, "We propose to go beyond all limits set or prescribed by taste, morality, or any other traditional value system shackling the minds of men. We pass beyond and go over boundaries of millimeters, screens, and projectors to a state of expanded cinema."

14 David Wojnarowicz and Tommy Turner, "Where Evil Dwells," 1985 (UbuWeb).

15 Maggie Nelson, *Art of Cruelty: A Reckoning* (New York: W.W. Norton & Co, 2011). Nelson explores the function of artists who hurt themselves and hurt their audiences through their work.

"staggering by the electrical gadgetry plants"; "in dive hotels with african [*sic*] posters or calendar on wall." [16] But the number of possible images and the diverse nature of the series suggest a vision that goes well beyond a story about Rimbaud as a tourist. In fact, the series does not suggest an overarching narrative beyond "Look! Rimbaud!" [17] In the most expanded version of the series, which would include more than four hundred images that have never circulated outside of the archive, remains the potential for a very different kind of Rimbaud. There, the Rimbaud figure is not always alone; Wojnarowicz photographed him with people. In particular, there are several photos of the Rimbaud figure with men of color. One explanation for the absence of the photographs of men of color in any larger history of the series might be that Wojnarowicz never included them in his exhibitions. Another possible explanation is that the whole of the series exists in the form of contact sheets as opposed to finished prints. Finally, it may be that photos of people engaged with the figure were outside of the most base dream of the series.

16 David Wojnarowicz, Series I: Journals, Jun 6-Aug 28, 1979; The David Wojnarowicz Papers; MSS 092; Box 1; Folder 11; Fales Library and Special Collections, New York University Libraries.

17 What has come to be known as the Rimbaud series begins with the publication of one photograph in May 1980 in the *Soho Weekly News*. One month later in the same newspaper, four more photographs were published. In February of 1981, sixteen photographs appeared in *Little Caesar*, a small magazine edited by Dennis Cooper. This selection included thirteen photos that had not yet been published. A solo exhibition at P.P.O.W. in 1990 included twenty-five Rimbaud photographs. In 1999, the New Museum held the retrospective *Fever*. Based on the exhibition checklist, the twenty-four photographs exhibited as *Arthur Rimbaud in New York* were "courtesy of P.P.O.W., New York (?) [*sic*]." See "Checklist." (It is not possible to compare the selection published by *Little Caesar* with that of the P.P.O.W. Gallery selection because there is no checklist for the 1990 P.P.O.W. show.) The most significant exhibition and publication of the series comes from Andrew Roth (both the name of the publisher and the name of the gallery). The book *Rimbaud in New York 1978-79* (2004) includes forty-four photographs and accompanied the exhibition of the same number. See Wojnarowicz, Tom Rauffenbart, et al.

There is arguably one image that has come to represent the series: the first published image. In May 1980, the *Soho Weekly* printed a photograph of someone in a derelict building shooting up, wearing a Rimbaud mask (fig. 1). It is not clear whether the Rimbaud figure is in ecstasy or has OD'd. The photo was printed in order to accompany an article about heroin use in the city. It focuses on artists who are using and suggests that ecstasy and death are close friends. The article ends with an interviewee on the phone who has just shot up, her speech peppered with the ellipses of her high, losing her capacity to continue the interview: "Where did you do it?" the interviewer asks. She replies, "In…my… arm…"

Figure 1. Rimbaud shooting up. *Soho Weekly News*, May 14, 1980.

Where speech fails, the body speaks. The image suggests that the poet Rimbaud and the person behind the mask are susceptible to a similar fate. The figure is leaning against a wall or sliding down it. Something is tied around his arm. The needle dangles from his skin. The arm is twisted, exposed to face the viewer, and the hand is not relaxed or dead but held where it stays. The body of so-called Rimbaud confronts us with what we were not able to prevent: "Look what I did," the body says. "Look at what you didn't see." "Look at what you didn't see coming."

The body says what the masked face cannot. The image confronts us with our failure to respond. A suicide says to the audience, "You're too late." "Rimbaud has injected himself and overdoses while propped up against a wall on which a target is mounted."[18] The bull's-eye sends our focus dilating into concentric rings. The body is the target but there's another target on the wall. A needle is a dart that lands in someone's arm. Is this an accident? The photograph suggests it is hard to tell what people mean to do when they overdose, and it accuses someone else of playing a role. In Olivia Laing's interpretation of the series, she surmises that it is "hard to imagine [Wojnarowicz's] Rimbaud being raped or forced to do anything against its will."[19] But the Rimbaud figure, as an object, an "it," is precisely being subjected to an indeterminable force.

The photograph's publication as a kind of news suggests there was a conversation about the self-destruction of artists. One month after the *Soho Weekly*'s publication of Rimbaud shooting up, the newspaper printed a centerfold of four different images from the series (fig. 2). Under the headline "Arthur Rimbaud in New York," the spread presents a Rimbaud whose sightseeing is in stark contrast to the tenor of the cover story, which emphasizes summer fun at crowded New York beaches. This Rimbaud represents repetition, imitation, and isolation.

18 Mysoon Rizk, "Constructing Histories: David Wojnarowicz's *Arthur Rimbaud in New York*," in *The Passionate Camera: Photography and Bodies of Desire*, Deborah Bright, ed. (New York: Routledge, 1998), 192. The only article dedicated to the series, "Constructing Histories" discusses this image as it was exhibited at P.P.O.W. in 1990. Selected and ordered by Wojnarowicz, this exhibition of twenty-five images tells a story, according to Rizk, in which Rimbaud arrives in New York via Coney Island and dies by overdose.

19 Olivia Laing, *The Lonely City: Adventures in the Art of Being Alone* (New York: Picador, 2016), 109.

In the photograph on the left, Rimbaud holds a gun in front of a mural of Jesus floating above the city, his arms outstretched. The photograph suggests Rimbaud's destruction of the icon of salvation. It is hard not to hear lyrics from Patti Smith's 1975 song "Gloria": "Jesus died for somebody's sins but not mine." Rimbaud's murderous gesture implies Jesus needs to be killed, again. The mural was meant to portray how Jesus embraces all, how his love is universal. Rimbaud, Wojnarowicz, and many queers, orphans, poor kids, etc. know this is not the case. For us, the open arms are more often an indication of an imminent judgment that can transform into murder. The only way to survive, the image suggests, is to kill before you get killed.

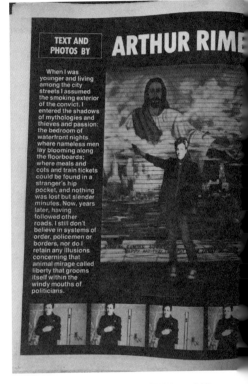

Figure 2. *Soho Weekly News*, June 18, 1980 (centerfold).

But this form of Rimbaud's disidentification with Jesus maintains their connection. Even while Rimbaud points a gun at the image of Jesus, the poet also imitates him. Rimbaud wears a scarf like his. His arm extends like the savior's. If Rimbaud were

to turn around and face the mural, he'd be close to a mirror image of Jesus. And Rimbaud holds a gun while Jesus bears the stigmata: one sacrifice resembles another. Rimbaud's imitation of Jesus suggests the former could be mistaken for, and become a substitute for, the latter. The bottom of the mural reads: "Jesus is coming soon. Happy are they that put their trust in him." Since it is Rimbaud who has come back from the dead to tour New York, to maybe, hopefully, save us from ourselves, we might rewrite this as "Rimbaud is coming soon. Happy are they that put their trust in him."

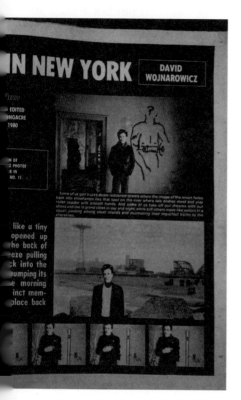

At the top-right of the centerfold, Rimbaud poses in front of a spray-painted figure with a needle in their arm; this recalls the photo, published one month earlier, of Rimbaud shooting up. The pierced or wounded arm also refers viewers back to the wounded palm of Jesus on the facing page. The repetition of these images refers to the mimetic nature of sacrifice, yet the photograph of graffiti also does something different. This figure has a question mark for a face. The question

of mistaken identity that erupts from the other photographs transforms into a question about whether identity exists at all. This is a portrait of a faceless person, perhaps the same one pictured in last month's paper. This is not the loss of identity but the lack of one.[20] The portrait suggests that suicidal fantasy has something to do with having nothing but an unanswered question as one's identity.

In both photos—the Jesus mural and the question-mark figure—Rimbaud is photographed in front of a representation of someone who is suffering, someone for whom there is no significant difference between suffering and pleasure, and someone who has died or will die because of, or on behalf of, suffering. The question mark undermines the singularity of sacrifice. Jesus could be Rimbaud could be anyone could be David Wojnarowicz. The substitutable wound suggests suffering in and of itself is not very particular or distinguishable from other suffering or even from other experiences. Murder, overdosing, and sacrifice are all part of the same soup. This is a series of violent substitutions that lead nowhere.

In the centerfold, I am taken in by the relay between photographs, where substitution is perpetual and emptying. The anthropologist and theorist Michael Taussig describes this kind of substitution: "When the human body, a nation's flag, money, or a public statue is *defaced*, a strange surplus of negative energy is likely to be aroused from within the defaced thing itself."[21] For Taussig, there is something erotic about this energy: "It is

20 Rizk, 190. Rizk suggests something more ambiguous. For her, the question mark signals "a confusion or loss of identity or individuality, much as the Rimbaud mask serves to scramble the protagonist's persona."

21 Michael Taussig, *Defacement: Public Secrecy and the Labor of the Negative* (Stanford, CA: Stanford University Press, 1999), 1.

with the power of mimesis that defacement achieves its highest, its most negative goals. Here again, with the mimetic, we see the intimacy of the bond that connects defacement to its object."[22] Taussig links this bond to magic, as when someone sticks a needle in a doll in order to hurt the person the doll represents.[23] This kind of defacement depends partially on knowing who or what is being represented.

Wojnarowicz photographed three friends and lovers wearing the mask: Brian Butterick, John Hall, and Jean Pierre.[24] But the question mark recalls that the mask effaces identity. Anyone can be Rimbaud. And so, too, no one is. Writing from other art critics and curators bears out this undecidability, too. Dan Cameron, curator of *Fever*, provides one kind of story about who is in the series:

> Inviting his friend and musical collaborator Brian Butterick to don a homemade mask of the French poet's face, Wojnarowicz photographed him in different New York locations as a way to evoke the spirit of an artistic forebear whose fervent embrace of the underground became a direct source of Wojnarowicz's writings.[25]

Here, Brian Butterick is a friend and musical collaborator and the only one who is being photographed. Rizk characterizes Butterick differently. "This series of photographs tells the stories of Rimbaud, Wojnarowicz, and his friend and lover Brian Butterick, an occasional heroin user, who wears a mask

22 Taussig, 43-44.
23 Ibid., 4.
24 Carr, 123-56. Carr traces many details regarding who is in which photographs and provides the most detailed account of the making of the series to date.
25 Wojnarowicz, Cameron, and Scholder, 7.

representing the French symbolist poet."[26] Rizk frames the series as telling stories about Rimbaud, Wojnarowicz, and Butterick and incidentally suggests Butterick's heroin use is the reason Rimbaud shoots up. Although Cameron and Rizk agree that Butterick wears the mask, we end up with a question regarding Brian: what's important about him? Heroin? Music? How do we know? Art historian Lucy Lippard is vague when she writes of "various friends wearing a sadly deadpan mask of the French poet…"[27] One scholar even assumes it is Wojnarowicz. "David's series of self-portraits wearing a Rimbaud mask from 1978-1979 include an image of David (Rimbaud) slumped against a wall with a needle hanging from his arm."[28] This both is and is not a mistake. Cameron refers to these sorts of pieces in Wojnarowicz's oeuvre

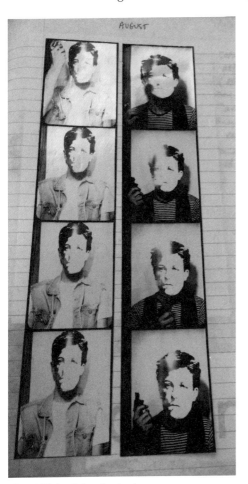

Figure 3. Rimbaud photo booth strip. From Wojnarowicz, Series I.

26 Wojnarowicz, Cameron, and Scholder, 46.

27 David Wojnarowicz and Lucy Lippard, *David Wojnarowicz: Brush Fires in the Social Landscape* (New York: Aperture, 1994), 9.

28 Patrick Moore, *Beyond Shame: Reclaiming the Abandoned History of Radical Gay Sexuality* (Boston: Beacon Press, 2004), 100.

as "surrogate self-portraits."[29] Ultimately, it does not matter who is behind the mask; it is the surrogacy that matters.

The notion of surrogate self-portraits is especially important when considering the pair of photo booth strips in Wojnarowicz's journal (fig. 3). To shift from defacement to surrogacy is to shift from a relationship between a person and an object to a relationship between two people, both of whom become objects to each other. Surrogate self-portraiture involves a mimetic relationship between photographer and the photographed.

In figure 3, Rimbaud has a gun in his hand. In figure 4, a detail of the strip, he points the gun to his chin. In some shots, Rimbaud simply waves the gun around: there is no clear direction. And, in others, the gun does not appear but remains a threat outside the frame. In these images, the Rimbaud figure becomes a surrogate for the photographer Wojnarowicz. When performance studies scholar Peggy Phelan writes that "all portrait photography is fundamentally performative," she grounds this claim in a description of how the model (the one being photographed) anticipates the desire of the photographer and tries to imitate it.[30] This begins a relay of vision and imitation, where the model imagines what the

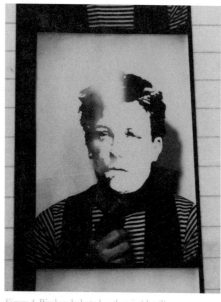

Figure 4. Rimbaud photo booth strip (detail).

29 Wojnarowicz, Cameron, and Scholder, 12.
30 Peggy Phelan, *Unmarked: The Politics of Performance* (New York: Routledge, 2006), 35.

photographer sees. The Rimbaud model, to stay with Phelan's structure, anticipates and imitates Wojnarowicz's desire, a masked person gesturing to suicide. The photo booth further dramatizes the model's unknown identity by suggesting the photographer's identity is also unknown. Who is the photographer in a photo booth? Where is the self of this self-portrait? What kind of desire is being expressed by someone wearing a Rimbaud mask pointing a gun to their chin? And to whom does this desire belong? Suicidal fantasy engages and tries to respond to the problem of too much surrogacy—of not being distinct: not being a photographer, not being a self, not having a face to call one's own, and not being able to own one's desires.

Wojnarowicz Is Not Rimbaud Is Not...

THE SIMILARITIES BETWEEN Wojnarowicz and Rimbaud have been outlined by many friends and art critics. In fact, nearly all of the writing on the series emphasizes the similarities between the two authors' biographies. They were both queer, angry, fearless regarding desire, and died too young. On the one hand, what Rimbaud and Wojnarowicz share is indisputable. On the other hand, such a tightly knit story of similitude is too easy to tell. It ties up the meaning of their lives so succinctly, I find myself both persuaded and resistant. In the foreword to *Rimbaud in New York 1978-79,* Wojnarowicz's partner and executor of his estate, Tom Rauffenbart, paints a picture of how the series reflects Wojnarowicz.

The Rimbaud series creates a world that defines the essence of David's life. His days as a teenage hustler on the old 42nd Street; sex and drugs on the abandoned Hudson River piers and the meatpacking district of lower Manhattan; walks along the boardwalk at Coney Island. Although the Rimbaud mask presents a blank, unchanging face, it seems to always be watching and absorbing sights and experience. Yet in the end, it remains alone.[31]

As Rauffenbart's view of the series makes clear, the photographs cultivate a specific interpretation of Wojnarowicz's life—an essence, a heart, a core truth of loneliness—which Rimbaud reflects. The Rimbaud mask "in the end, remains alone," and Rauffenbart describes Wojnarowicz elsewhere in the essay as a "loner." Through all of its permutations and contexts, the mask seems defined by neglect. Lippard describes Rimbaud as a "violently disruptive genius, author of *A Season in Hell*" who "was homosexual, alcoholic, had lived on the streets and wandered Europe and North Africa; he died at thirty-seven (of carcinoma according to diagnosis, but it was likely syphilis)," and Rimbaud's death, she continues, was "almost exactly a century before Wojnarowicz's own death from an equally painful and horrible disease."[32] To have Rimbaud's identities listed in this way (homosexual, alcoholic, lived on the streets), in the service of describing what Wojnarowicz shared with him feels loose, too simple, knowing. There is also something exciting about Lippard's mastery over the authors' biographies. Like going to a horror movie in order to be scared, we watch with our hands over our eyes and peek through our fingers. I feel like this is what Lippard's view suggests: look, but pretend you're not looking.

31 David Wojnarowicz, Tom Rauffenbart, Andrew Roth, and Jim Lewis, *Rimbaud in New York 1978-79* (New York: PPP Editions, 2004), n.p.
32 Wojnarowicz and Lippard, 9.

The century between Rimbaud and Wojnarowicz's births is *not* an indication that these authors' ends are connected to their beginnings through cosmic and chronological magic. Streamlining the lives of Wojnarowicz and Rimbaud and suggesting they followed similar paths, paths that led to similar ends, risks losing that which has gone unsaid and unseen. Lippard's description fills too much in. This unwitting approach to the series—something that pulls the distant and distinct strands of decades and difference together—is not unique. Similar emphases on identification emerge in more recent writing on Wojnarowicz. In "Fleshing Out the Grid," an essay for a 2012 exhibit that included photographs from Wojnarowicz's series, John Chaich writes, "Wojnarowicz died of AIDS in 1992, the same year I came out, near the same age he was when he photographed his first published works, *Arthur Rimbaud in New York 1978-79.*"[33] Chaich's identification with Wojnarowicz mirrors how critics discuss Wojnarowicz's identification with Rimbaud.

The series sets in motion a narrowing of the wide scope of time and difference, urging us to identify with the collapse of difference. The psychoanalyst and writer Adam Phillips would ask, what might this kind of identification be a solution for? Understanding oneself in relation to another through a special and externally determined connection—like the coincidence of dates—helps close a gap that is otherwise stretched by distance and lack.

Discussing Rimbaud and Wojnarowicz like they are perfect reflections for each other can become a way to talk about

[33] John Chaich, "Fleshing Out the Grid," in *David Wojnarowicz: The Rimbaud Series : Hunter Reynolds : Survival Aids*, David Wojnarowicz, Hunter Reynolds, and John Chaich, eds. (New York: P.P.O.W., 2012), n.p.

suicide without talking about it. In Carr's description of why Wojnarowicz chose Rimbaud for the series, she ultimately leans on the passive voice.

> He identified with the poet. They'd been born a hundred years apart—Rimbaud in October 1854 and David in September 1954. Both were deserted by their fathers and unhappy with their mothers. Both ran away as teenagers. Both were impoverished and unwilling to live by the rules. Both were queer. Both tried to wring visionary work out of suffering. David just didn't yet know the rest—that he would soon meet an older man and mentor who would change his life (as Paul Verlaine had changed Rimbaud's), and that he too would die at the age of thirty-seven.[34]

Looking back on Wojnarowicz's life, Carr ascribes a passivity to it that is conceptually similar to the inevitability of death, but the life Carr describes also sounds like a premature surrender, one that depends on deathly and deadly environs. Even though both Rimbaud and Wojnarowicz are the subject of nearly every sentence, she writes as if they were passively subjected to their lives. They were born. They were deserted. It is worth noting that Carr writes that they "*tried* to wring visionary work out of suffering."[35] They both arguably tried and succeeded. It is as if Carr finds herself persuaded by the music of their passivity and so she does not want to change the tune. She even emphasizes what David did not know about his future as if this were a special feature of his knowledge or lack of knowledge, as if someone else could have known his future. The effect of Carr's simultaneous description of both Rimbaud and Wojnarowicz is morbid. They were tossed about by life. And, moreover, life treated them like

34 Carr, 133.
35 Ibid., emphasis added.

they were already dead. The idea of being dead before one has died speaks implicitly of suicidal fantasy, a searching that attempts to link one's material conditions with their psychic conditions. This goes something like, "I might as well die because I already feel dead."

Identifying with an uninterrupted narrative of loneliness, a feeling as a continuous fact, is a problem. It is not sufficient precisely because it is too much. The identification is overkill. The differences between the image of Rimbaud, the person Rimbaud, the image of David Wojnarowicz, and the person David Wojnarowicz are incalculable. That Rimbaud and Wojnarowicz are loners is something we can be seduced by, frightened by, compassionate with, and more. It is also an essence we should ask about, a version of the story that calls for interruption.

I don't dispute the loneliness of David Wojnarowicz. I cannot speak to that, and surely Wojnarowicz's lovers and close friends can and should. But I can suggest that there is more going on. Testifying to the truth of Wojnarowicz's predilection for feeling alone is one way to understand the series. But imagining that *Arthur Rimbaud in New York* is a form for expression of *that* self ignores the suicidal fantasy: the problem of not having a self, needing to find a way to represent not having one, and the rage that belongs in the picture.

Moreover, emphasizing loneliness and death can make Wojnarowicz sound like a sad lamb compared to other possible descriptions. A friend of Wojnarowicz, the art writer Carlo McCormick, describes his work in terms of a "provocatively angry, frustrated, melancholic and lonely expression of personal

alienation."[36] Another friend and collaborator, Fran Lebowitz, is even more bold when she writes, "David, instead of turning into a serial killer, turned into an artist,"[37] and later, in the same essay, "David's rage was murderous."[38] These views of Wojnarowicz and his relationship to feeling and art-making are in concert with Jack Halberstam's interpretation of Wojnarowicz's writing.

> Wojnarowicz writes of murderous desires and desires for murder; he calls for bloody and violent change and he does so in what he calls "the language of disintegration." For Wojnarowicz, language itself becomes a weapon, a tool, and a technology and the act of imagination becomes a violent act.[39]

Although Halberstam rightly emphasizes violence here, all these versions of Wojnarowicz and his art are still too quarantined by their own unity.

Seduced by the similitude of biography, sometimes Lippard, Carr, and others, including myself, miss what we cannot see. What we know about Wojnarowicz's life—that his father kidnapped him and his siblings, that his father pretended to kill himself and then actually killed himself; that Wojnarowicz was queer and thought of killing himself when he got caught making out with a boy as a teenager; that he was often homeless and worked as a hustler in order to survive; that he had art teachers and johns that looked out for him—should not obscure how his work invokes suicidal fantasies in order to represent the experience of being erased. The series shows us that the experience of

36 Wojnarowicz and Lippard, 13.
37 Ibid., 74.
38 Ibid., 77.
39 Jack Halberstam, "Imagined Violence/Queer Violence: Representation, Rage, and Resistance," *Social Text* 37 (Winter 1993): 193.

being erased, of not being seen, of being unsure one exists at all, is difficult to say and show because the condition of the experience will be violated if it is shown or said too clearly.

In *David Wojnarowicz: A Definitive History of Five or Six Years on the Lower East Side*, Jennifer Doyle writes that Wojnarowicz's work "paradoxically layers despair with a sense of commitment to offer us a catachresis—a gesture towards the impossibility of representing what it is he represents."[40] Carr acknowledges this gap when she states, "So his childhood wasn't as bad as he said? I think it was worse."[41]

Andrew Roth succeeds in creating a significant conceptual distance between Wojnarowicz and Rimbaud in his essay in *Rimbaud in New York 1978-79*. He also begins to suggest how the mask troubles the identification between Rimbaud and Wojnarowicz.

> [Wojnarowicz's] identification with the poet was no doubt a matter of wishfulness based on affinity. Still, it's not clear who the person wearing the mask in these pictures is, whether it's Wojnarowicz himself, or a friend or lover, or *even if it's one protagonist rather than a series of interchangeable ones.*[42]

The difficulty of discerning one from a series is precisely what formally links these photographs to the problem suicide attempts to solve: the wash of suffering that destroys the singularity of experience and identity.

Although the series can feel like an endless iteration of the same, the mask gives us more than its mirror-like effects. The

40 Sylvère Lotringer and Giancarlo Ambrosino, *David Wojnarowicz: A Definitive History of Five or Six Years on the Lower East Side* (New York: Semiotext(e), 2006), 228.

41 Carr, 5.

42 Wojnarowicz, et al., *Rimbaud in New York*, n.p. (emphasis added).

mask is a prop. And, as a prop, it teaches us how to survive and become better witnesses to self-erasure. While the photographs engage fantasies of suicide, the mask posits that a certain survival has already occurred. As Lippard is careful to note referring to the mask in the archive, "(it has survived)...."[43] Once it has been removed from the body, the mask becomes a symbol of survival. On, it renders a person's expressiveness mute. Off, the mask can be related to as an object, independent of anyone hiding behind it. In the archive, it can be held and I can be careful not to mishandle it. I enter a realm of fantasy with the object; I imagine what it might have felt like to wear it and what it feels like not to wear it. I do not occupy the position of having been, or needing to be, wholly represented by its image.

Wojnarowicz's comments on the series guide us in this direction.

"I felt, at that time, that I wanted it [the series] to be the last thing I did before I ended up back on the streets or died or disappeared. Over the years, I've periodically found myself in situations that felt desperate and, in those moments, I'd feel that I needed to make certain things...."[44]

"I'd feel that I needed to make certain things": to make certain things as in particular things, certain kinds of things, but also to make things in themselves certain, to lean toward existence, to an object in space that had not disappeared, to make certain a ground. At some point, one cannot live if they are uncertain about things in and of themselves. Imagining his own disappearance, Wojnarowicz suggests he went back to making sure things existed,

43 Wojnarowicz and Lippard, 9.
44 Carr, 133.

could exist, or could survive his hand in them. Wojnarowicz makes the Rimbaud mask certain. And it can be a prop that strengthens our resolve.

The Rimbaud mask suggests how any of us come to survive: by being held and supported, by being provided a substantial enough ground to push off from. By being positioned in relation to a world in which there are no others—they are not there or they do not see the figure or they refuse to see him—the mask asks that we appreciate the genuine gift of social life, where social life is commensurate with life, where there is no surviving without a society to carry us.

Survival by Mask

IN LACAN'S 1949 lecture on the mirror stage, he narrates an infant's encounter with its mirror image. He describes himself as

> reflect[ing] upon the striking spectacle of a nursling in front of a mirror who has not yet mastered walking, or even standing, but who—though held tightly by some prop, human or artificial (what, in France, we call a *trotte-bébé* [a sort of walker])—overcomes, in a flutter of jubilant activity, the constraints of his prop in order to adopt a slightly leaning-forward position and take in an instantaneous view of the image in order to fix it in his mind.[45]

Lacan describes a powerful moment for the child in front of the mirror. A prop supports the child, then the child triumphs over it in order to first gather and then hold an image of herself, *without props*, in her mind. A vision of the infant as free, as embodying a brief, physical independence from "the

45 Jacques Lacan, *Écrits: The First Complete Edition in English*, trans. Bruce Fink (New York: W.W. Norton & Co., 2006), 76.

constraints" of the prop, emerges. This physical independence from the prop leads the infant to imagine they are strong enough to be this independent always and entirely: an ideal of the infant's wholeness is what comes to be fixed. While the *image* of Rimbaud functions as the image in the mirror stage, the *mask* is the kind of prop that makes the so-called fixed image possible. It hints at the need for something other than the image itself.

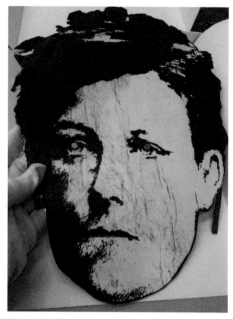

Figure 5. Rimbaud Mask. Wojnarowicz, Series XI.

The prop, in Bruce Fink's translation, holds the child tightly. Something or someone that is not the same as the child is bonded to the child and the child is bound by this prop, but not indefinitely or dangerously. The child needs the prop in order to lean away from it and toward its own image. This prop is more like a prosthesis than the homogenizing Rimbaud mask. The Rimbaud *image* appears to bind without release when it adheres too closely to the identity of the person so many have imagined it reflects: Wojnarowicz. When the *mask* can be separated from the image, engaged with as prop, we can lean into the fantasy of the mirror without conflating the image with the prop. The prop produces distance from the image by fashioning support that permits getting close to, but not falling into, the image.

The mirror stage marks the infant's movement into a social world. Lacan suggests both that the mirror stage ends and that its ending begins something new. "This development is experienced as a temporal dialectic that decisively projects the individual's formation into history,"[46] where history is defined later as social. "This moment at which the mirror stage comes to an end inaugurates [...] the dialectic that will henceforth link the *I* to socially elaborated situations."[47] Lacan's theory of the mirror stage is both a theory of childhood development and a theory of how any of us continues to be and become throughout our lives. The prop, in contrast to the image, is history, is "socially elaborated situations," social life or society. The prop is that which bolsters and assists in anyone's capacity to retain their identity well enough to continue to live. The Rimbaud mask as a Lacanian mirror-stage prop is not what provides the onlooker with an identity, but it is that which permits enough distance to fix an image of oneself in the first place. It is also a tool that gives the person who wears it protection from being fully identified with an image.

In *Persons and Things*, literary critic Barbara Johnson reads the myth of Narcissus in the context of the mirror stage. Since Narcissus dies as a consequence of looking at his image, unlike the infant in the mirror stage, Johnson must shift the emphasis in Lacan's theory from one about development and social life to one that defines a person's failure to be without needs. For Johnson, Narcissus falls in love with his image not because he is especially beautiful but because images do not have needs. This, of course, is no love at all. Narcissus' attachment to an image—a thing—kills him.

46 Lacan, *Écrits*, 78.
47 Lacan, 79.

> The identification with a beautiful form is an identification of life itself as imperfection. Only the inanimate has the fixity, the lack of feeling, the lack of need that corresponds to the unchanging ideal. While in love with an image that never had needs, Narcissus himself disregarded his own, and died behaving like the non-living thing he loved. [48]

Johnson's reading of Narcissus' death rightly focuses on his relation to his image as "the non-living thing he loved." Toward this end she draws the following conclusion:

> What happens in the mirror stage is the conflating of libidinal investments with beautiful forms: the fantasmatic and the aesthetic are henceforth the 'reality' of the self. And the definition of 'person' would then be: the repeated experience of *failing to become a thing.* [49]

Johnson's definition of a person is negative. She tells us that a person is defined by failure, their incapacity to be without needs. She bases her definition of a person, in part, on Narcissus' neglect of himself. In other words, Johnson's definition of a person keeps a negative relationship to needs intact. Ultimately, persons are not, for Johnson, defined by any present qualities; persons are defined by what they cannot be.

Johnson's translation of Lacan's theory into a conceptualization of what makes persons begs an important question: what helps a person feel like a person? What helps people feel alive and, thus, behave like they're alive? What, for instance, might have interrupted Narcissus drowning in his own image to cause him to remember that he had needs? What allows anyone to feel alive

48 Barbara Johnson, *Persons and Things* (Cambridge, MA: Harvard University Press, 2008), 58.

49 Johnson, 59.

and so to continue to want to live? Our understanding of the difference between life and death can be separate from our analysis of the relationship between persons and things, but they converge for Johnson in a way that goes unacknowledged.

In addition to the example of Narcissus, who "disregarded his own [needs]"—a passive form of suicide—Johnson provides three lines from a Sylvia Plath poem, "Edge," in order to explore another person who has lost the capacity to need.

> In the poem that ends her volume of complete works, Sylvia Plath, too, seems to find that perfection in death:
>
>> The woman is perfected.
>> Her dead
>>
>> Body wears the smile of accomplishment....
>
> Death, however, is not the only way to achieve the stillness of the ideal. What happens in the mirror stage is the self's identification with a still image, which then becomes the version of superiority that the living self will try to equal.[50]

Johnson aims to de-emphasize death and turn our attention to the image in Plath's poem: the "smile of accomplishment" that indicates perfection, the perceived gestalt of the infant in Lacan's mirror stage. Johnson begins by describing death and proceeds to imagine the "stillness of the ideal," which is a dead woman's body for Plath, but this stillness does not reflect the infant in Lacan's mirror stage. On the contrary, what Lacan describes is someone moving. The child is "in a flutter of jubilant activity," the experience of new clumsy life in a "leaning-forward position."[51] Lacan also describes the "spatial capture manifested

50 Johnson, 58.
51 Lacan, *Écrits*, 76.

by the mirror stage."[52] Something holds and beholds us. Lacan's lecture recalls something active rather than passive and in three dimensions rather than two.

Johnson's literary examples, the myth of Narcissus and Plath's "Edge," not only emphasize a connection between death and personhood; they also highlight deaths that, in part, were the responsibility of the ones who died. But Johnson does not make a distinction between death and suicide. The distinction is paramount. Suicide involves hate and murder, even if by means of a passive neglect, and it is directed at someone, even if that someone is unidentifiable. Death is a universalizing term; death takes the hate out of suicide and murder.

The woman in Plath's "Edge," rather than being merely dead, invokes a woman's suicided body—Plath's in particular. Plath left all her present, past, and future audiences with an image of her that dissolves into her self-orchestrated end. There is much to say about Plath and suicide even though it seems like we always say too much about it.[53] Her end is magnetic. Johnson is pulled toward an end that feels inevitable when she refers to the location of "Edge" in Plath's complete works as the poem that "ends her volume." In other words, if Johnson had not wanted to make an implicit argument about suicidal fantasy and the reduction of persons to persons without needs, she could have found a poem about the perfection of a woman in death that was not written by a woman who killed herself. She ends the essay by turning to Heinrich von Kleist, another writer who killed himself.

52 Lacan's mirror-stage is complex, and Johnson has chosen to emphasize an aspect of the image—its stillness—at the cost of recognizing how much Lacan's language turns readers to movement, both in the infant and in psychoanalysis.

53 See Jacqueline Rose, *The Haunting of Sylvia Plath* (London: Virago Press, 2008).

Johnson's interpretation of a person's relationship to things arguably has something to say about suicide: fantasies of suicide imagine that persons can live without needs and that a life with too many unmet needs makes someone feel like a thing, which as a primary experience of life is unsurvivable. Her reading of the mirror stage develops a theory not only about the thing (the image) and its relationship to persons; she also suggests people can kill themselves by acting like things without needs. So, we must be something other than images, objects, and things. And the prop is a thing that allows the infant—and, later on, any of us—to use it. The prop permits an activity, a kind of agency, on the part of the one who is making use of it. Further, the prop of the Rimbaud mask also refers us to the role of witness; it is *something that is used* but also *someone who allows their self to be used.* The prop can keep Rimbaud and Wojnarowicz from being reduced to their own image. It is not the body that is real compared to the mask. In fact, the prop bolsters the body enabling us to imagine that the body is real. We need the props we need to survive.

Witnessing the Unknown

IN 1998, CAMERON described Wojnarowicz as "both one of the most influential and one of the least recognized artists to emerge from New York during the 80s." [54] Almost 10 years later, Jennifer Doyle bemoaned that his work was getting short shrift, that it was "easy to dismiss" and "stubbornly under-analyzed," in particular because of its relationship to autobiographical sources. [55] Wojnarowicz's use of autobiography asks for a particularly difficult

54 Wojnarowicz, Cameron, and Scholder, 1.
55 Lotringer and Ambrosino, 227.

kind of witness: the one who must see that which cannot be seen. This distinguishes Wojnarowicz's series from the work of one his better-known contemporaries, Nan Goldin, whose *Ballad of Sexual Dependency* asks for a witness to a social life that is already visible in the work itself.

In *An Introduction to Visual Culture,* Nicholas Mirzoeff writes on witnessing and voyeurism in the work of Nan Goldin (born 1953) and street photographer Weegee (1899-1968). He marks an important shift in photography that Nan Goldin and other members of the Boston School initiated in that it "changes the nature of photography itself from the act of a voyeur to that of a witness." He goes on to clarify what distinguishes the witness:

> A witness physically participates in a scene and later reports on it, whereas the voyeur tries to see without being seen. While Weegee's photographs might serve as evidence in the judicial sense, Goldin's witness her scenes in the ethical sense of testifying to existence. Rather than take her camera out into the street and document what she finds, Goldin takes her pictures indoors in the apartments of her social circle and in their public meeting places.[56]

The crime photographer Weegee drove around listening to the equivalent of police scanners and would arrive at a crime scene to take his pictures before the police did. His participation is very different from Goldin's. Goldin is already out with her friends or, as Mirzoeff emphasizes, she's in with her friends, in the bedroom, in the bathtub, even on the toilet. She also photographs herself at her most vulnerable, with a black eye, and in the hospital for rehab. Goldin's *Ballad of Sexual Dependency* testifies

56 Nicholas Mirzoeff, "From Photo Noir to Post-Photography," in *An Introduction to Visual Culture* (New York: Routledge, 1999), 81-82.

to existence, as Mirzoeff writes. More specifically, it creates an extended family of queers, children, and lovers. One can see a story of a life develop, for example, in her many photographs of writer and actress Cookie Mueller. We see her in a wedding dress in one image and beside a casket in another. Goldin keeps track of the people she loves, and her work goes far beyond that of a witness to that of an impassioned, intimate participant in a lively social world full of loss. Goldin is doing the work of seeing in the fullest sense of the word.

Turning from Weegee and Goldin to the Rimbaud series, we can start to see that Wojnarowicz inches us toward a different understanding of the witness, as he places greater importance on the negative, or what or who goes unseen, than on positive, testifying proof. The Rimbaud series suggests witnessing is an act that requires strain because suicidal fantasy models a wish that rejects a plea for witness at the same time as it fashions one. The logic that unfolds sounds like this: "I'd like to take my life so that both myself and others may see how much I was not seen"; "I will have finally garnered the witness I always needed, a witness to isolation, rejection, loneliness, being turned away from, and I will have made those who are responsible suffer." The mask in the series is the prop that gestures to the possibility of being seen in isolation.

In contrast, what is moving about Goldin's photographs is how populated the world is. They are not simple photographs, but they are easier to be with than a series in which the desire for witness and to witness is wildly ambivalent.[57] In Wojnarowicz's

57 Jennifer Doyle, *Hold It Against Me: Difficulty and Emotion in Contemporary Art* (Durham, NC: Duke University Press, 2013). Doyle discusses artworks that make viewers into witnesses. Wojnarowicz's photographic work is among the works Doyle

work, there is both a refusal to appear and a gesture to the potential to both appear and disappear. This ambivalence is important for survival.

Although we do not see the face behind the mask, in the earliest published photograph, we see the person's ear. This ear is a whisper of appearance, a reluctant invitation to the audience to say what they see, an unidentifiable person who possibly committed suicide. The ear also suggests the survival of the author. The posthumously published *Rimbaud in New York 1978-79* reproduces the mask of the face of Rimbaud on the cover and an image of the inside (reverse) of the mask as the back cover so that we are confronted with the materiality and artificiality of the mask. We see the black tape used to hold the rubber band in place that wrapped around the mask-wearer's head. We see the yellow sweat stains and dirt on the white interior of the mask. We also see the tiny slit in the mouth that permits the very rare occasion in which the mask is photographed with an open mouth. There are holes in the eyes of the mask so that the person wearing it can see.

Wojnarowicz, I imagine, took care of the mask. He made it in 1978 and he died in 1992. Through all the lousy Lower East Side apartments, with leaks and roaches, through all of Wojnarowicz's own wandering and experience of homelessness, he took care of this mask (among other things that make up his archive). Unlike his paintings which were bought and sold, he held onto this relatively fragile mask, a high-quality photocopy on poster board. One might imagine this preservation as a sign of care—the kind of care a witness can offer, in the colloquial sense of looking after someone, without filling the void, without forcing an identification.

refers to and she makes an even finer distinction between witness and participant by examining work that makes the viewer into something undesired by the viewer.

Wojnarowicz did not use the mask in his later photographic work. In fact, one of his last photographs, taken in 1991, is of his own face partially buried in the ground. There is no question about the liveliness of the person in the photograph. He is squeezing his eyes closed to keep the dirt out, a wrinkle in his brow. In addition to what Robert Sember decides is "Wojnarowicz's attempt to create an image of his dying" as someone with AIDS, the portrait also produces a fantasy of feeling how one is still living, feeling the earth graze one's face. [58]

I HAVE A TATTOO of an artwork by David Wojnarowicz. In fact, I know two other poets with tattoos of his work. Is there something about Wojnarowicz's relationship to representation that initiates our identification? Or is it our desire? Something exists in Wojnarowicz's work and life that sets a charge to his viewers, and we respond by adding more, giving more of that which the work calls for. Some of us see ourselves inside his work—in part because we see the selves in need of the most love, which translates to fantasies of our relationship with him and his memory. Yet these fantasies are never without the strangeness of Wojnarowicz's symbols that harbor a time when one was never sure if their life could be saved, or if it was worth surviving.

The series urges us to forget what we think we know about Rimbaud, Wojnarowicz, and ourselves. Placing Rimbaud's image in a new context, as the series does, questions what we

58 Robert Sember, "Seeing Death: The Photography of David Wojnarowicz," in *The Ends of Performance,* Peggy Phelan and Jill Lane, eds. (New York: New York University Press, 1998), 35. Sember writes of the portrait, referred to as the Chaco portrait because it was taken in Chaco Canyon in New Mexico: "The image splits the instant to recall a past when Wojnarowicz was still alive while also projecting a future when he will be dead."

know of identity. Wojnarowicz's photographs reflect on what cannot be known or seen in any moment: that anyone might survive that which feels unsurvivable.

In his essay "The Sleep of Rimbaud," Maurice Blanchot describes the poet's legacy and suggests obliquely what Wojnarowicz's series helps bring into being.

Rimbaud does not ask poetry to produce beautiful works, or to answer to an aesthetic ideal, but to help man go somewhere, to be more than himself, to see more than he can see, to know what he cannot know—in a word, to make of literature an experience that concerns the whole of life and the whole of being.[59]

Wojnarowicz's Rimbaud engages the idea that we can know more than we know, which also invites the possibility that we may need to know much less than we think we do. Suicidal fantasy wants both: my dream of taking of my life is based on my knowing that the future will be just like the past and that neither time nor change exist; I am also looking to fashion the unknown by taking myself out of time. The mask interferes with this dilemma. It asks us to look beyond what we know of ourselves and to reflect on the damage severe forms of certainty and uncertainty produce. Surviving, Wojnarowicz suggests, depends on our capacity to witness those who are vulnerable to repeated erasure without asserting that we know what it's like.

59 Maurice Blanchot, "The Sleep of Rimbaud," in *The Work of Fire*, trans. Charlotte Mandel (Stanford, CA: Stanford University Press, 1995), 155.

Works Cited

Ball, Hugo, and John Elderfield. *Flight Out of Time: A Dada Diary*. Berkeley: University of California Press, 1996.

Blanchot, Maurice. "The Sleep of Rimbaud." *The Work of Fire*. Translated by Charlotte Mandel. Stanford, CA: Stanford University Press, 1995. 153-61.

Carr, Cynthia. *Fire in the Belly: The Life and Times of David Wojnarowicz*. New York: Bloomsbury USA, 2012.

Chaich, John. "Fleshing Out the Grid." *David Wojnarowicz: The Rimbaud Series : Hunter Reynolds : Survival Aids*. Edited by David Wojnarowicz, Hunter Reynolds, and John Chaich. New York: P.P.O.W, 2012.

"Checklist for 'Fever: The Art of David Wojnarowicz,'" *New Museum Digital Archive*. Accessed July 15, 2016. [https://archive.newmuseum.org/print-ephemera/8481]

Doyle, Jennifer. *Hold It Against Me: Difficulty and Emotion in Contemporary Art*. Durham: Duke University Press, 2013.

Halberstam, Jack. "Imagined Violence/Queer Violence: Representation, Rage, and Resistance." *Social Text* 37, (Winter 1993): 187-201.

Jamison, Kay Redfield. *Night Falls Fast: Understanding Suicide*. New York: Knopf, 1999.

Johnson, Barbara. *Persons and Things*. Cambridge, MA.: Harvard University Press, 2008.

Lacan, Jacques. *Écrits: The First Complete Edition in English*. Translated by Bruce Fink. New York: W.W. Norton & Co, 2006.

Laing, Olivia. *The Lonely City: Adventures in the Art of Being Alone*. New York: Picador, 2016.

Lotringer, Sylvère, and Giancarlo Ambrosino. *David Wojnarowicz: A Definitive History of Five or Six Years on the Lower East Side*. New York: Semiotext(e), 2006.

Mirzoeff, Nicholas. "From Photo Noir to Post-Photography." *An Introduction to Visual Culture*. New York: Routledge, 1999. 76-85.

Moore, Patrick. *Beyond Shame: Reclaiming the Abandoned History of Radical Gay Sexuality*. Boston: Beacon Press, 2004.

Nelson, Maggie. *The Art of Cruelty: A Reckoning*. New York: W.W. Norton & Co, 2011.

Phelan, Peggy. *Unmarked: The Politics of Performance*. New York: Routledge, 2006.

Rimbaud, Arthur. *Illuminations*. Translated by John Ashbery. New York: W.W. Norton & Co, 2011.

Rizk, Mysoon. "Constructing Histories: David Wojnarowicz's *Arthur Rimbaud in New York*." In *The Passionate Camera: Photography and Bodies of Desire,* edited by Deborah Bright, 178-94. New York: Routledge, 1998.

Robb, Graham. *Rimbaud: A Biography*. New York: W.W. Norton & Co, 2000.

Rose, Jacqueline. *The Haunting of Sylvia Plath*. London: Virago Press, 2008.

Sember, Robert. "Seeing Death: The Photography of David Wojnarowicz." In *The Ends of Performance,* edited by Peggy Phelan and Jill Lane, 31-51. New York: New York University Press, 1998.

Taussig, Michael. *Defacement: Public Secrecy and the Labor of the Negative.* Stanford, CA: Stanford University Press, 1999.

Taylor, Marvin J. *The Downtown Book: The New York Art Scene, 1974-1984.* Princeton, NJ: Princeton University Press, 2006.

Wojnarowicz, David. Series I: Journals, Jun 6-Aug 28, 1979; The David Wojnarowicz Papers; MSS 092; Box 1; Folder 11; Fales Library and Special Collections, New York University Libraries.

———. Series XI, Subseries: A; The David Wojnarowicz Papers; MSS 092; Box 90; Fales Library and Special Collections, New York University Libraries.

Wojnarowicz, David, Dan Cameron, and Amy Scholder. *Fever: The Art of David Wojnarowicz.* New York: Rizzoli, 1998.

Wojnarowicz, David, and Lucy Lippard. *David Wojnarowicz: Brush Fires in the Social Landscape.* New York: Aperture, 1994.

Wojnarowicz, David, Tom Rauffenbart, Andrew Roth, and Jim Lewis. *Rimbaud in New York 1978-79.* New York: PPP Editions, 2004.

Wojnarowicz, David, and Tommy Turner. "Where Evil Dwells." (Video, 1985.) *UbuWeb.* Accessed July 13, 2016. [http://ubu.com/film/wojnarowicz_evil.html]

Zedd, Nick [Orion Jeriko]. "The Cinema of Transgression Manifesto." *Feast of Hate and Fear.* 1985. Accessed July 16, 2016. [https://www.dissidentreality.com/articles/cinema-transgression-manifesto]

Acknowledgments

An excerpt of this text, with edits and additions, was published by *Jacket2* as part of the series of commentaries "Suicidal Fantasy and the Life of the Author."

I took the photographs of David Wojnarowicz's works and archival materials at the Fales Library & Special Collections. I am grateful to P.P.O.W. and the Estate of David Wojnarowicz for their permission to reproduce them here.

Thanks go to the Ugly Duckling Presse collective; colleagues from 2015's School of Criticism and Theory; and faculty at the University of Wisconsin-Madison: Monique Allewaert, Jill Casid, Lynn Keller, Aida Levy-Hussen, Fréderic Neyrat, Mario Ortiz-Robles, and Ellen Samuels.

Our Rimbaud Mask is dedicated to Jordan Dunn, Lewis Freedman, and Andy Gricevich: Oscar Presents 4 Life!

Our Rimbaud Mask

Images from the David Wojnarowicz archive at New York University's
Fales Library & Special Collections are reproduced here by permission
of P.P.O.W. and the Estate of David Wojnarowicz.

ISBN 978-1-946433-20-6
First Edition, First Printing, 2018
Edition of 1000 copies

Ugly Duckling Presse
The Old American Can Factory
232 Third Street, #E-303
Brooklyn, NY 11215
www.uglyducklingpresse.org

Distributed by SPD/Small Press Distribution
a nonprofit literary arts organization
www.spdbooks.org

Design by Don't Look Now!
Set in Bulmer with Recta titles
Printed offset and bound by McNaughton & Gunn
Paper from French Paper Company

Ugly Duckling Presse is a 501(c)(3) nonprofit publisher for poetry,
translation, experimental nonfiction, essays, performance texts, and books
by artists. Our programs are made possible by grants from the New York
City Department of Cultural Affairs, the New York State Council on the
Arts, and the National Endowment for the Arts, with additional support
from foundations and individuals. UDP is a member of the Community of
Literary Magazines and Presses [CLMP].

OUR RIMBAUD MASK

$1

D1475791

ART CRITICISM / ESSAY
UGLY DUCKLING PRESSE